This photographic thing has changed the e[...]
o deeper and deeper. It will go through ever[...]
ashion, medicine, space, ESP, for peace, against peace, entertainment,
elevision, movies, all of them – you will not find one without photography. Also,
hotography is an art form which means: human beings expressing their
nderstanding of and connection with life, themselves, and other human
eings.' Lisette Model

isette Model was born Elise Seybert to a Jewish family in Vienna in 1901. Her
ather Victor Seybert was a wealthy and cultivated man who owned property in
taly and a large house with a fine library in Vienna. Introduced to the world of
ulture early in her life, Lisette hoped to become a concert pianist and started
ormal piano lessons at the age of 17. Vienna was a great musical city, home to
.ichard Strauss and Gustav Mahler, and Model was fortunate to study with
rnold Schoenberg in 1920–1. The great experimental composer of atonal
usic and inventor of the twelve-tone row was a gifted teacher. He did not
ecessarily instruct his students in his own musical theories, but tried to get
1em to think structurally and logically about basic musical ideas that would be
ree of the dramatics, poetics and ornamentation of late nineteenth-century
usic. He made a great impression on Model, who stated that he was her only
eacher of any significance. He instilled in her a sense of the importance of
eing alive to the present. Years later, she would quote Schoenberg's advice:
To reveal the twentieth century you must have what Schoenberg called a
odern nervous system. That is, you must have both of your feet in this time.'

uring the First World War, Model's family lost money on their land holdings.
fter Victor Seybert died in 1924, her mother, Félicité, decided to return to her

native France. Along with Lisette's sister, Olga, they settled in Nice on the Côte d'Azur. Still interested in music, Lisette went to Paris in 1926 to study singing which she pursued for the next seven years. However, gradually becoming less convinced of her musical abilities, she took up painting, studying briefly with the painter and art critic André Lhote in the early 1930s. But by 1933, she had turned to photography. Her intention was not to produce images as an artist but to train herself as a darkroom technician in order to earn money. Model realized that the political realities of Europe in 1933 might force her to leave at any moment, and photography, as a skill, was transportable. She appears to have had limited formal instruction. She was taught by Olga, who was a trained photographer, and she formed a friendship with the first wife of André Kertész Rogi André, a Hungarian photographer living in Paris. André taught her to use Rolleiflex, urging her only to photograph subjects she was passionate about.

Model's growing absorption in photography suggests that she may have been more than a casual witness to photographic activity during her years in Paris. Through André, she would have known the work of Kertész and Brassaï both eloquent photographers of the city. She would also have been aware of Atget's photographs of Paris neighbourhoods. Although he had died in 1927, she probably saw the selection of his work shown in Paris in 1928. Her admiration for the German photographer John Heartfield may also date from this time in Paris, where his anti-Nazi photomontages were exhibited in 1935.

However much Model would later claim to be innocent of the traditions and techniques of photography, such innocence was willed and a product of her milieu. 'The most successful photographs are not those that require the most trouble,' wrote Carlo Rim, editor of the Parisian magazine *Vu*

n his article 'On the Snapshot' published in 1930. In keeping with this esthetic, Model wished to maintain in her photographs the freshness of the mateur snapshot. But if this casualness was her goal, she was nonetheless reatly aware of the potential of the darkroom. It was in the printing process hat she created her ideal image, cropping the negative, magnifying parts of the vhole, tilting the easel of the enlarger, burning in and dodging (masking an area f the print during exposure). Technique for its own sake was not interesting to er, but the manipulation of the image was part of the creative process.

fter buying her first cameras (she used a Leica and a Rolleiflex), Model began o experiment, photographing and processing prints of scenes and people bserved in Paris and its environs. In the summer of 1934, she went to stay with er mother in Nice. Near her mother's house, she portrayed the rich visitors – rench, German, Russian – who went there to sunbathe and rest. Model's is ot a flattering study of a healthy, gymnastic beach culture, the type of Utopian ision promoted between the wars. Her wealthy subjects are not young, beauti- ul and fit; they are the antithesis of grace and elegance. The South of France's nforgiving sun glares on their bulky bodies, which their clothes strain to over. These photographs have come to be regarded as presenting a damning iew of indolent upper-middle-class Europeans. They form a collective portrait f people who, in their privileged state of lazy unmindfulness, were responsible or the imminent collapse of their world.

hese 'Promenade des Anglais' pictures were published in 1935 in the noted rench journal *Regards*, accompanied by a text (which she did not write) that vas openly critical of the upper-middle class. In October 1938, Lisette isited New York with her husband, Evsa Model, a Russian-born graphic designer

and painter. Like so many other European artists during the war years of th
early 1940s, they decided to make a life for themselves there. Lisette tried to ge
a job as a darkroom technician, showing her work to the photographer Ralp
Steiner, who was also Art Director of the liberal *PM's Weekly*. It was hi
admiration for her work, particularly his decision to publish 'Promenade de
Anglais' in 1941, that launched her career as a photographer. Her ambitio
simply to be a technician came to an abrupt end.

It had taken just two years for Model to get her work published in the Unite
States. In those two years, living on the family money that remained, sh
began to make new pictures. Her series of photographs 'Reflections' an
'Running Legs', which she began around 1939, were inspired by the streets o
New York, a city to which she and her husband had taken at once. Both the lay
ered, photomontage-like images of store windows and their reflections, and th
graphically conceived views of legs walking the streets, were strong, modernis
compositions and looked extremely experimental. But once again, they were th
products of Model's snapshot technique and each image was achieved throug
a single negative.

Model's photographs from the 1940s to the 1950s fit comfortably into the 'Nev
York School' of photography, a term coined several decades later by the criti
Jane Livingston. This broad category describes the images made by a group o
photographers working between 1936 – the time of the classic, documentary
style Farm Security Administration works of Walker Evans – and 1955, whe
Robert Frank's alienated and arbitrarily framed pictures emerged in the book *Th
Americans*. New York School work has been characterized as achieving a combi
nation of toughness and romanticism. It is located between the poles of socia

documentary — centred around the Photo League (1936), a school, gallery and publication dedicated to photography as a vehicle for social change — and sophisticated photojournalistic styles cultivated in certain magazines (such as *Harper's Bazaar* by Alexey Brodovitch, its Russian-born Art Director and a respected teacher). The term is a short-cut for referring to many photographers who worked roughly in this style, including Kertész, Weegee, William Klein and Louis Faurer. Their work coincided with the beginnings of institutional support for photography by museums and curators (the Museum of Modern Art established a Department of Photography in 1940), a time when an art market for the medium had yet to develop. Model's photography has been placed in this category by virtue of her involvement with the Photo League and the Brodovitch circle. And it certainly has shared characteristics with New York work of that time, both formally and conceptually. Her determination to maintain a certain remove from the projects of other photographers suggests, however, that she would not have been happy with such categorization.

By 1943, Lisette and Evsa Model had moved to Greenwich Village. The sociable Evsa spent his time in bars and coffee shops, and painting abstract views of the city. Both frequented the cafés and cabarets on Delancey Street, which Model often photographed, as well as other locations on the Lower East Side where the streets reminded her of Europe.

From 1941–5, Model's photographs were primarily observations of New York. These images were included in exhibitions at the Museum of Modern Art, whose curator Beaumont Newhall had been introduced to her work by Steiner and Brodovitch, and the Photo League — her exhibition for which had drawn enthusiastic praise from the photography critic Elizabeth McCausland. They

also appeared in the pages of *Harper's Bazaar*. Her first photograph to be published in this magazine was *Coney Island Bather* (page 43), a picture of a bulky woman in a bathing suit playing to the camera. Her subject could not have been more different from the svelte models in fashion photographs. But Model did not consider this photograph a social document. She would not concede to the category of the documentary, even though she was aware of the critical force behind it. 'Documentary' was a term newly coined in the late 1930s and coincided with the rediscovery of the work of Lewis Hine, who had been recording social conditions in New York and elsewhere from the beginning of the century, not just for the simple purpose of reform, but treating photograph as an art through which to learn to see the world differently. Though Model's photographs of residents of the Lower East Side are easily appropriated into Hine's tradition of humanistic photography, it is her distinction from this category that is significant. From her European roots she derived a deep interest in society, but she did not see her photographs as a way of opening the public's eyes to situations that begged for reform; an aim to a greater or lesser extent of US documentary photography in this period.

The milieu of *Harper's Bazaar* thus seemed the most congenial and nurturing to the development of her work and was Model's major source of income from 1941 to 1955. Brodovitch and editor Carmel Snow wanted to change the generally predictable look and contents of the magazine and make it truly fashionable in all areas of culture from new art to new writing. This was facilitated by Brodovitch's knowledge of contemporary art and his personal acquaintance with many artists. Model, who rarely took catwalk photographs, was hired as a regular photographer and her work contributed to the general sophistication integral to the modishness that was the magazine's main concern.

As another way of supporting herself, Model tried straight photojournalism; her pictures of war rallies appeared in *Look* magazine in 1942. But the standard subjects of photojournalism, such as civic events, were not her forte. In the congenial atmosphere of *Harper's Bazaar* she was able to exploit her interest in the idea of glamour. She was friendly with others on the staff, including George Davis, the fiction editor, who introduced her to the nightclub Sammy's Bowery Bar where she took some of her most famous photographs, and Dorothy Wheelock, the theatre editor, who sometimes gave her theatre and nightclub assignments. Glamour and the social dynamics attached to it drew her to photograph the public spaces and events of New York — hotels, bars, restaurants, Nick's, a jazz spot, and the steak house Gallagher's — where glamour was, for her, an essential ingredient. She found it as a distant shadow in the dishevelled costumes of people on the skids, in the highly artificial glare of drag balls and in the splendid auras of the doyennes of taste.

However, Model did not always work on assignment and, around 1946, she photographed the residents of the Murray Hill Hotel, the Westminster Kennel Club dog show and the International Refugees Auction, making images depicting an older, more or less aristocratic generation whom she observed with an ambivalent mixture of nostalgia and satire.

Recognized as a major talent, Model was embraced by the photographic community which comprised, among others, the artists Ralph Steiner, Berenice Abbott and Ansel Adams, the critic Elizabeth McCausland, and Beaumont Newhall, the curator of the Museum of Modern Art where she exhibited frequently. Ultimately, not wanting to work on assignment and unable to conform to the growing conservatism of *Harper's Bazaar* under William Randolph

Hearst, she stopped active work for the magazine around 1946. If the Photo League was not the centre of her professional and personal life, she nonetheless maintained connections with it, exhibiting there and attending, along with Evsa, classes given by Sid Grossman, its director. By the late 1940s, the Photo League was being viewed with suspicion by the Attorney General's Office and by 1947, its photographers were on the blacklist. Model seems to have managed to keep her political concerns private, which is not to suggest that she was without deep liberal sympathies, as her photographs indicate. Of the general air of suspicion existing in the US at the time, she commented, 'It was terrible. You didn't know what to photograph.' Even the fact that she photographed black performers such as the dancer Pearl Primus made her art appear risky and less desirable for publication. The shift towards conformity effected by the Cold War on the tastes of Americans in a sense impacted on Model's career. Increasingly, the projection of an ideal middle class led to a rejection of eccentricity and otherness. However, unlike overtly political photographers such as Sid Grossman, she did not become unemployable.

The growing subjectivity and move towards abstraction among painters and photographers at this time has been analysed as a defence against the attacks made by the forces of McCarthy in the United States. Although Model did not have a programmatic political agenda, she was insistent on her own freedom to photograph what she found interesting, even if it was not commercially viable in the new era of 1950s conservatism. Since the economics of survival were key, she turned to teaching, making a virtue out of necessity. She was an inspired teacher and, in her forthrightness, was a role-model for many of her students. In turn, their fresh outlook and concerns stimulated her work. Model's teaching began in 1949 in the photography department established by Ansel

Adams at the California School of Fine Arts, San Francisco. While there, he established what would become one of the cornerstones of her teaching – field trips taken with her students into the city to find photographic subjects. This aspect of her teaching illustrated her belief that a naturalistic encounter was one of the fundamentals of photographic realism. She marvelled at the profound exchange between the subject of a picture, the photographer's view and the camera's transformation of this into a photographic image.

In 1950 Model participated in a symposium on the subject 'What is Modern Photography?' at the Museum of Modern Art, chaired by Edward Steichen. The following year she published her views in the *New York Times*. She was not interested in experimental photography per se, such as she might have known it in Europe or in the abstract photography of Minor White and others in the United States. 'So-called experiments in photography,' she wrote in the *Times*, merely produce imitations of old-fashioned or modern painting (incidentally ignoring all that has happened in between) in which photography itself is given little recognition.' She felt it was not necessary to experiment – that is, change the look of the world – since so much transformation was already at work between the photographer, the lens and the subject. She continued, 'Whereas the human eye observes one object after another, by focusing first upon one, then on others in turn, the lens, or the camera eye, takes in all the objects at once, though they be situated in ten different planes, and can do this in a fraction of a second on a two-dimensional surface.'

Model's teaching at the New School for Social Research in 1951, which she continued up to her death in 1983, brought her into contact with many who were to become important photographers in their own right, including Larry Fink,

Rosalind Solomon, Lynn Davis and Bruce Weber. But her most famous pupil was Diane Arbus. Arbus and Model enjoyed the same critical relationship as she herself had shared with Schoenberg, in which teaching is understood in its broadest terms — as education in the philosophy of art and life.

In the late 1960s, Model's philosophy began to take on a spiritual dimension. She attended several lectures and read the notebooks of Jiddu Krishnamurti (1895–1986) whose work, particularly *Education and the Significance of Life* (1953), had been a favourite of Brodovitch's. As author Philip Lopate recorded in an unpublished interview, Model's concept of the snapshot, as she articulated it, becomes a supreme instance of Krishnamurti's idea of living in the moment: 'I am a passionate lover of the snapshot, because of all photographic images it comes closest to truth ... the snapshooter['s] pictures have an apparent dis-order and imperfection, which is exactly their appeal and their style. The picture isn't straight. It isn't done well. It isn't composed. It isn't thought out. And out of this imbalance, and out of this not knowing, and out of this real innocence toward the medium, comes an enormous vitality and expression of life.'

The standard view of Model's career has been that her teaching eclipsed her energies as a photographer. As the years went on, she edited her own output herself and only showed specific bodies of work in the exhibitions and commer-cial situations that came her way towards the end of her life. But some of her later series have been unjustifiably overlooked. For example, her 1949 photo-essay for *Ladies Home Journal* on the subject of divorce in Reno, a group of images of women who appeared disaffected, insecure, worldly and vulnerable, spoke of a new social reality as strongly as many of the images in Frank's *The Americans*. Her photographs of the sculptor Reveron's life-like

dolls, taken in his studio in Venezuela, and her 1950s images of fragments of ancient sculpture in Rome reveal an attempt to configure psychological readings of inanimate figures.

As the cabaret life of postwar New York waned and the youth culture of jazz fans and beatniks dawned, Model, always aware of nightlife as a microcosm of society, took many photographs of this world. Her involvement with this milieu coincides with the beginnings of the Civil Rights movement, and she may have been thinking of jazz as largely a product of black culture. Model hoped to publish a book of these photographs, which would have included a poem by Langston Hughes and an essay by the jazz critic Rudi Blesch, but it never materialized due to lack of financial support.

The jazz world provided Model with one of her masterpieces – her portrait of Billie Holiday in her coffin (page 123). Holiday, the great blues singer, had lived through notoriety and scandal, having been turned away from the Stork Club and banned from the company of its white clientele by the arbiter of status, Sherman Billingsley, its owner. Dead from a drug overdose, Holiday is shown dressed in white, lying in her coffin. Once an aspiring singer herself and later a photographer of singers, there was a special poignancy in Model's images of this subject – the performer who is forever silenced. Even in death, she is beautiful. As an aficionado of glamour in all its guises, Model had found in Holiday her perfect subject. To Model, glamour was a modern term for the vitality, the larger-than-life dimension that she sought to portray in all her subjects. It was the quality that made the ordinary extraordinary. In America, she found a glamour industry that through the media promoted the star. Photography's role was to serve up images of this glamour as examples to be emulated or dreamt about.

Model seemed to absorb this as a special quality of American (particularly New York) life as soon as she arrived there. Her photographs of shop-window reflections often present fashion mannequins and the displays of fancy stores on Fifth Avenue as embodiments of the style of the moment. It was not that Model was interested in fashion as it is commonly understood — wearing the right thing at the right time — but in fashion as performance; glamour as an enhancement of life. The portrait of Holiday, strong in its evocation of the enduring eloquence yet physical ephemerality of glamour, has shaped the work of other photographers now seen as encapsulating social conditions at the end of the twentieth century. One such example is Peter Hujar's great portrait of the female impersonator Candy Darling on her death bed.

Many years later in 1964, Model continued to pursue her interest in glamour when, encouraged by Diane Arbus, she applied for and succeeded in winning a Guggenheim grant. Her subject was 'Photographic studies of the social and historic history of our time', emphasizing particularly 'Glamour: The Image of Our Image'. Aided by the grant, she travelled to Los Angeles and Las Vegas. Yet she made no images that satisfied her enough to promote them to the status of finished works. When the opportunity presented by the Guggenheim grant failed to bring economic success or widespread fame, Model's active photographic career tapered off and her energies were absorbed by teaching.

Model had a complex relationship with the idea of her own fame as an artist, and with the notion of an artistic career in photography. She downplayed her technical abilities and thought of her early successes as having come about casually, almost by accident. This anti-careerism and near-amateurist position was deliberate, as if to suggest that the wisdom of the photographer came from

n inner philosophical core that was lacking in the careers of the technically roficient or ambitious members of the photographic community. However, she lways believed that she lacked the discipline, integrity and above all intelligence to be a great artist.

y the 1970s, the growing interest in photography's history and the expanding opularity of the medium as an art form helped to draw Model out of her self-mposed obscurity. The fact that she had taught Arbus no doubt contributed to a enewed interest in her work, but her imagery in its own right also struck sympathetic chord in the culture of the 1970s. Its direct, near-bawdy frankess and earthiness, its snapshot quality, its sympathy for street life made it ppealing to a generation that was simultaneously rediscovering the press hotography of her colleague Weegee, a figure who fascinated even the ultra-ashionable Andy Warhol. The seedy glamour of Model's photographs of nightclub evotees, dancing transvestites and the hermaphrodite at Hubert's in New York ecame known to the photographers of the sexually liberated 1960s.

rom the late 1970s up to her death, Model made herself available for lectures nd gave interviews about her opinions on art, photography and life, though he strongly controlled what she allowed to be printed. Her final achievements vere a commercial show at the Sander Gallery in Washington DC in 1976 and a najor retrospective at the New Orleans Museum of Art in 1982. When she died 1 1983, she was still living in her basement apartment in Greenwich Village, ts walls, floors and furniture painted by her husband Evsa in squares and ectangles of red, green, blue and black.

Bois de Boulogne, Paris, 1933–8. 'She sits in the Bois de Boulogne ... and pray That is a Bible – but I can identify this kind of a woman. She is from the haute bourgeoisie. She is very well-off or well-off, probably a widow – she has nothin to do but live and pray with a kind of elegance and distinction ... ' (Model, Belle interview, 1979).

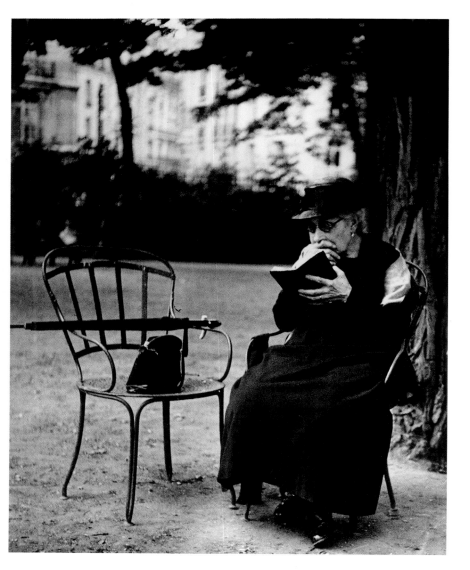

Blind Man in Front of Billboard, Paris, 1933–8. This portrait of a blind ma[n]
resembles a caricature by the nineteenth-century French artist Daumie[r;]
it records the overlooked. The man is elegantly dressed in shirt, tie and stra[w]
hat, yet his label reduces him to a type, dependent on charity. Model catche[s]
the dour set of his mouth and emphasizes his hands, which hold a small box fo[r]
collecting coins.

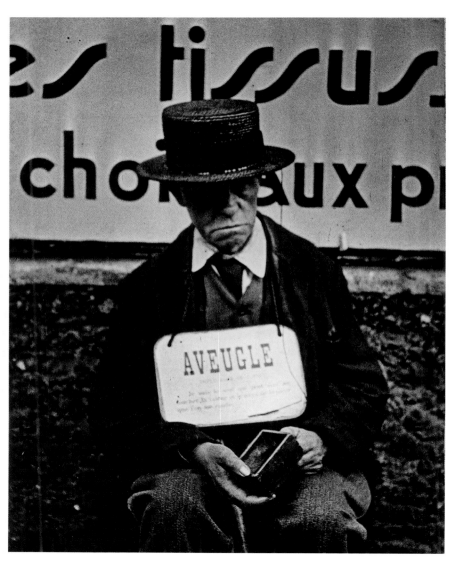

Blind Man Walking, Paris, 1933–8. On the crowded streets of cosmopolita Paris, Model captures a blind man negotiating his way through the crowd, whic has backed off to give him space. The expressions of those in the crowd recon indifference and annoyance. Unaware, the blind man, with his stick like a prophet staff, conveys grace and spirituality in the midst of the hurry of modernity.

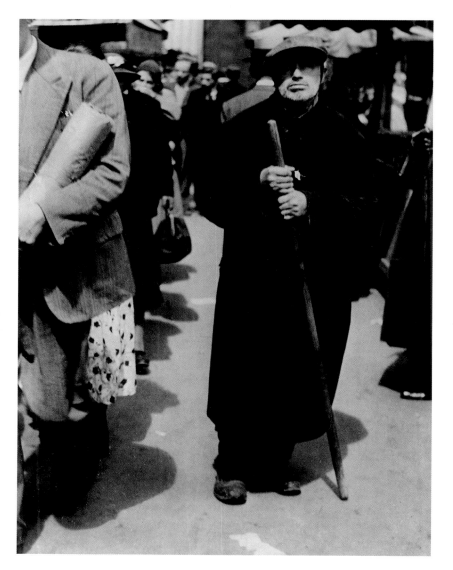

Vincennes Zoo, Paris, 1933–8. Model encouraged her students to photgraph animals, which could, she felt, act as surrogates for human beings. In thphotograph, which takes a while to decipher, the face of a seal is shot in closup; it is a witty abstraction, simultaneously primitive and sophisticated. Modwas certainly aware of movements in abstract art, since in this period she mand married Evsa Model, a painter and designer of Russian origin who livedParis and was involved with Constructivist artists. However, she never pursua completely abstract style. Her starting point was always something identifiabNonetheless, abstract visual thinking – scale, composition, point of viewconditioned the structure of her mature photographs.

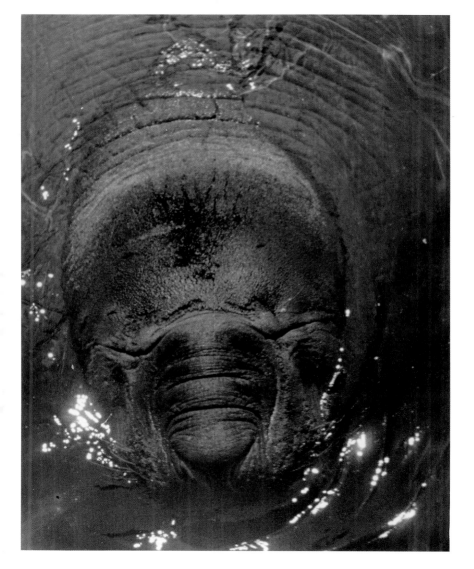

Destitute Woman Seated on Bench, France, 1933–8. When her student expressed qualms about the ethics of photographing the poor, Model would counsel that they could take the picture only if they could imagine being the person on whom their lens was focused. Model never thought of herself as a political photographer striving to achieve social change, but she clearly had sympathy for those she chose to photograph. She seemed to maintain an emotional distance, however, allowing other elements to emerge, especially humour and irony, which could often displace a response of simple pity. In that respect, this photograph is somewhat uncharacteristic in its pathos. Since the old woman's face is engulfed in shadow, it is her doubled-over posture and her hands – one bare, the other gloved – that evoke the extreme despair of her condition.

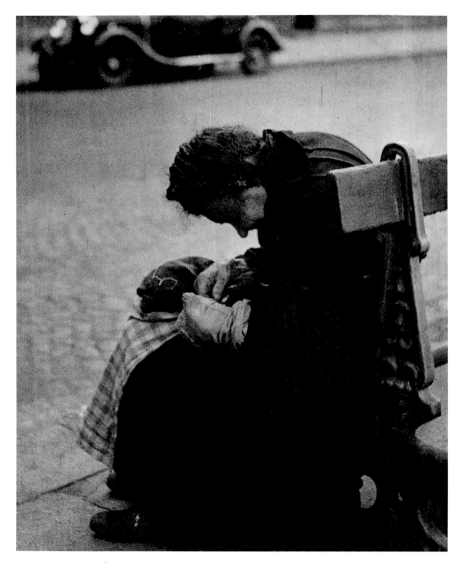

Man with Pamphlets, Paris, 1933–8. In the 1930s, Model used a medium format, hand-held Rolleiflex camera and learned to trust her instincts in finding subjects. In the printing process, she manipulated and cropped her negative, tilting the paper as a means of achieving an interesting picture. She would claim that it was during this process, rather than at the time it was taken, that picture came to have meaning. Here, she has fixed a passing moment in the urban flux; the street is carved out around the bulk of the moustachioed man, dwarfing a shadowy figure who moves diagonally into the density of the city.

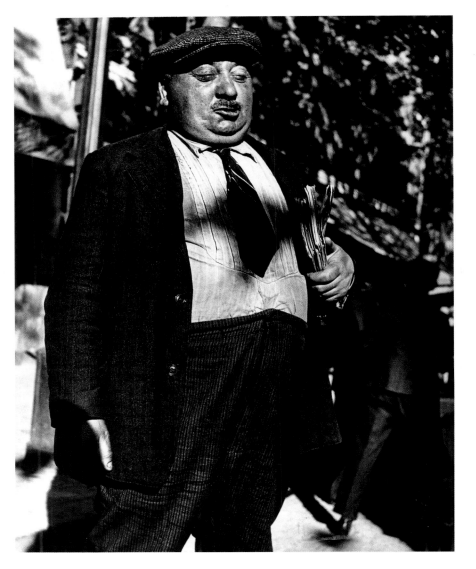

Circus Man, Nice, France, 1933–8. This photograph was taken in Nice, where Model's mother Félicité Seybert had gone to live in 1926. Her interest in the formal qualities of the photograph – scale, the plasticity of the human figure and the surface as a contrast of tones and graphic patterns – predominates over psychological or social statement. She positions the camera so that the circus man, whose heavy body looms over the facades of the buildings across the street, is the major force in the urban setting. The striped shirt and the back of the bench read as geometrically drawn receding planes.

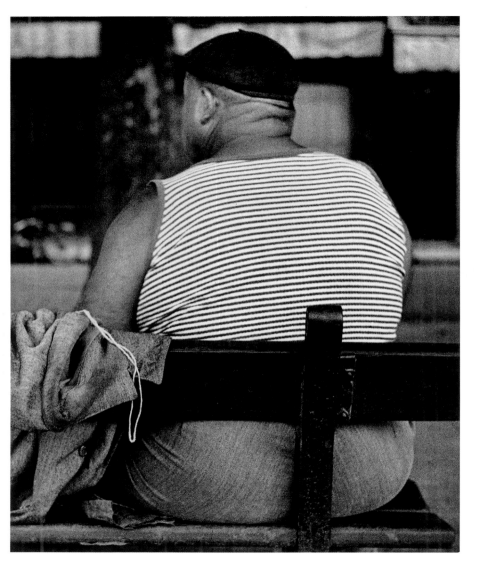

'Promenade des Anglais', Nice, France, 7 August 1934. The Promenade de Anglais attracted a wealthy European clientele who came to Nice to enjoy it climate. Elegantly dressed, they relaxed in their chairs in the sun. In contrast t this particularly passive form of leisure activity, the taut-skinned man who i the subject of this picture holds himself on guard, gazing warily back at th photographer. Taken as a group, Model's 'Promenade des Anglais' photograph formed a visual document of a somewhat decadent Europe on the verge of th Second World War. A selection of these photographs was published in Februar 1935 in the French publication *Regards*.

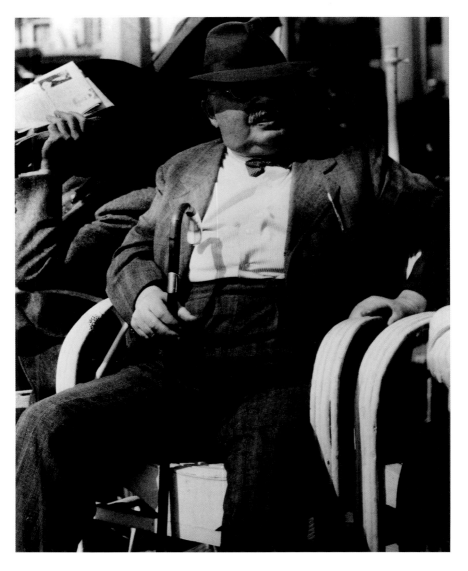

'Promenade des Anglais', Nice, France, c.1934. This woman is so large that the bench on which she perches seems almost unable to hold her. Model often photographed corpulent people. It was a quality that seemed to attract her, both as a plastic, sculptural value and as a metaphor for complacency. This photograph, published in 1935 in the lively political journal *Regards*, was accompanied by a critical text, not written by Model: 'The Promenade des Anglais is a zoo, to which have come to loll in white armchairs the most hideous specimens of the human animal.' It was also published in January 1941 by the liberal New York magazine *PM's Weekly*, accompanied by an article with a similar editorial viewpoint, entitled 'One Photographer's Explanation of Why France Fell'.

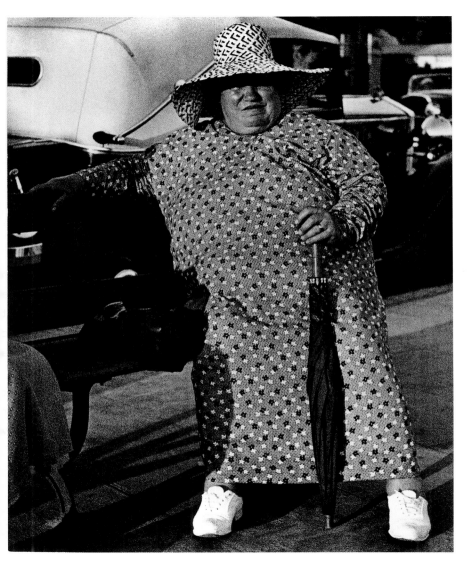

'Promenade des Anglais', Nice, France, c.1934. Not all of Model's 'Promenade des Anglais' photographs are satirical. There is an elegiac feel to this picture of an older man whose graceful slouch, soft, old clothes and worn shoes betray shabby elegance. Here, Model shows her mastery of light and tonality. One of the pleasures of the photograph is that it captures the bright sun and midday shadows by the water. Seemingly unaware of Model's camera, the subject's absorbed gaze is directed into the distance, at a moment when he is intently alert to either inner thought or distant activity.

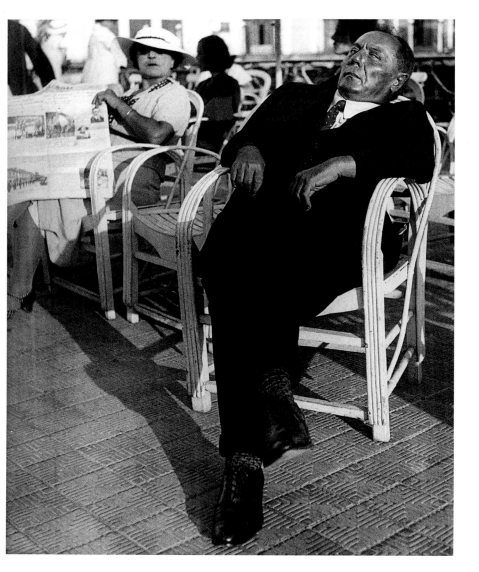

'Promenade des Anglais', Nice, France, c.1934. This woman provides a striking contrast to many of Model's 'Promenade des Anglais' subjects, whose clothes and age convey a fading Europe. With her peroxide, bobbed hair, sunglasses, revealing swimsuit, polished toenails and dangling cigarette, she was perhaps in her prime – an exemplar of the new, liberated woman of the 1920s. Now, she seems world-weary and cynical. The photograph appeared on the cover of *PM Weekly* in January 1941. Its caption explained that 'the photographer snapped this high society Frenchwoman at a "very elegant tea place" along the Promenade des Anglais in Nice'.

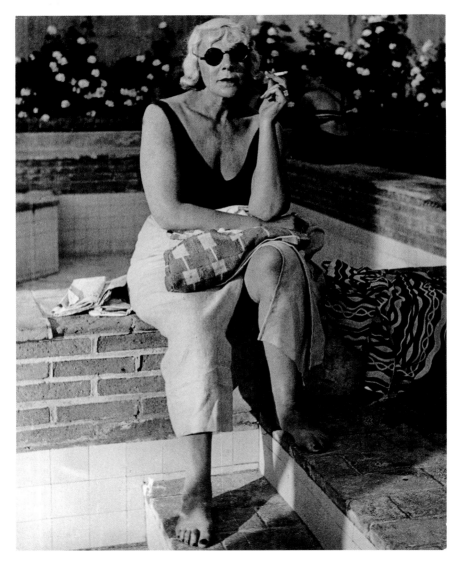

Famous Gambler, French Riviera, France, c.1934. Model was drawn to exagger
ations. Here, the focus of her satirical eye is the large body of the black-cla
female gambler sitting imperiously in a café. Nice had been home to casino
since the eighteenth century, and gambling, along with the pleasant climate
drew visitors to the resort. The woman's body seems proof of her compulsion
the outcome of the sedentary life of the habitués of the gambling tables. Th
photograph was published in September 1938 in the illustrated magazin
Lilliput. Even before she left Europe in 1938, Model had found that magazine
were receptive to her idiosyncratic vision.

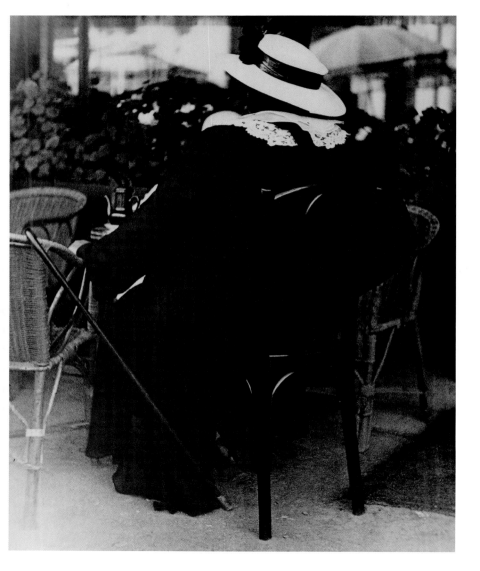

First Reflection, New York, 1939–40. This image captures the urban dynamism and density of experience that Model loved about her new home, New York City, where so many things occurred simultaneously. It is the first in the series of shop-window pictures 'Reflections' which spanned many years. Recalling Atget's photographs of Parisian shop windows, and the more experimental photomontages created by European photographers in the early 1920s, this picture records the contents of the window, the reflections of the cars on the street, a man looking in the window and the surrounding architecture. It was acquired by the Museum of Modern Art in 1940.

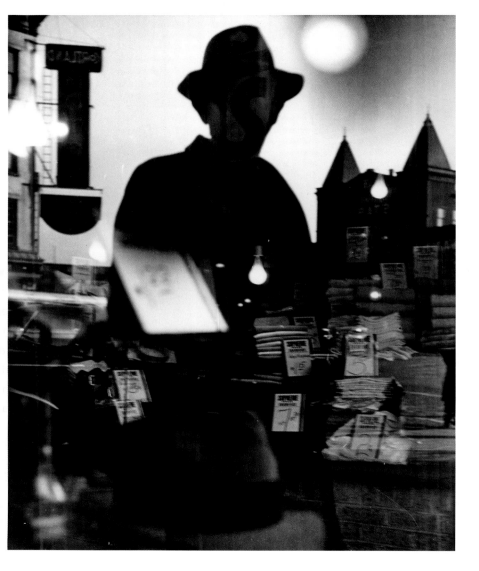

Coney Island Bather, New York, 1939–41. The subject of this photograph is the antithesis of a fashion model, which perhaps makes it surprising that the image appeared in *Harper's Bazaar* (illustrating an article called 'How Coney Island Got That Way'). However, under editor Carmel Snow and Art Director Alexey Brodovitch, the magazine expanded beyond the usual fashion news to include interesting feature articles and coverage of vanguard art and literature. Although never covering fashion, Model was to work on assignments for the magazine throughout the 1940s. The pleasure of posing for the photograph and of swimming in the surf shows in the face of the woman, whose monumental body recalls Model's earlier photographs.

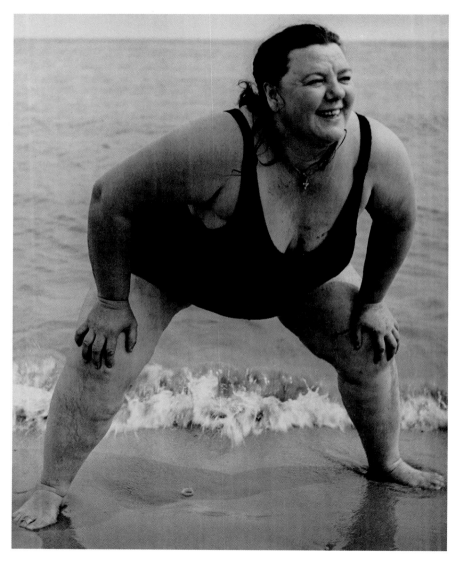

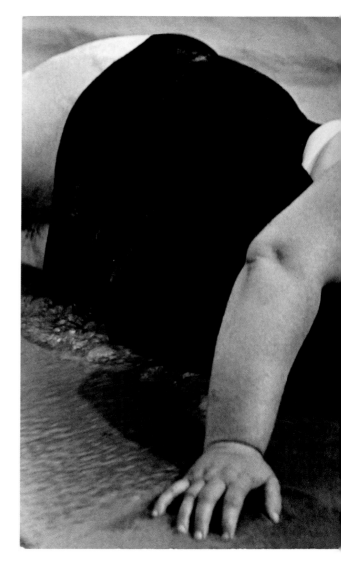

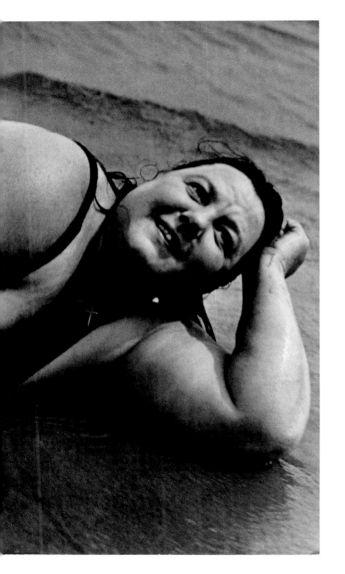

(previous page) Coney Island Bather, New York, 1939–41. In the 1950s, Model made larger prints of her work in a 16 x 20 inch format. The copy of the reclining bather that exists in this size lends greater sculptural presence to her monumental body. Yet the exchange between photographer and subject, registered by her trusting, open and engaging facial expression, is as important as the sculptural simplicity of the image.

Wall Street, New York, 1939–41. The Neoclassical facade of the New York Stock Exchange forms a backdrop for this communion between an inanimate eighteenth-century stone statue and a contemporary banker. Both represent the power of Wall Street and share a similar expression – hard, stern and unsmiling. The outstretched hand of the statue seems to bless or annoint the modern Titan who suggests the power and importance of wealth in America. In her 1950s photographs of Roman sculpture, Model again brought ancient stone figures into a psychological relationship with modern contexts.

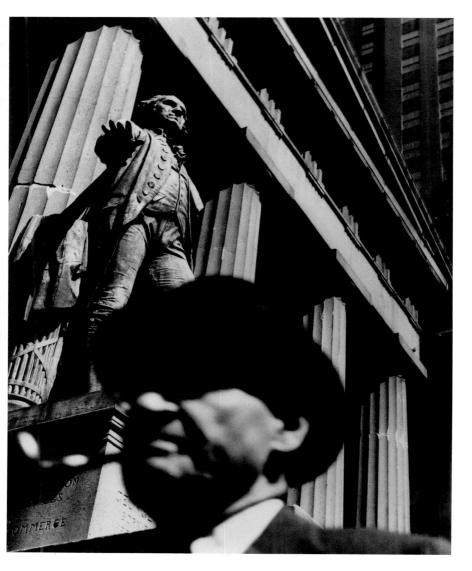

Frank Sinatra, New York, 1939–44. A major star whose appearances wer regularly attended by thousands of fans, Sinatra here appears contemplative an distinguished, wearing a neat suit and shirt, his expression withdrawn behind pair of discreet glasses. As if looking for an uncharacteristic side of Sinatra order to reveal something unexpected, Model avoids the more clichéd approac of photographing him in performance. The strict simplicity of this image devoid of the trappings of celebrity.

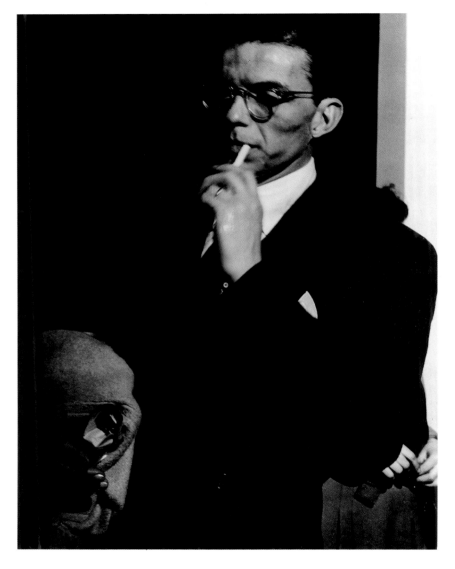

Window, Bergdorf Goodman, New York, 1939–45. Fifth Avenue inspired hundred of Model's pictures. Of this she recalled: 'I really wanted to send a photograp to my sister in France, to show her what Fifth Avenue was. I was a little b disappointed, with such a small street and such a big reputation. I put myself i the middle of that and I couldn't photograph that. And accidentally I looked int one of those magnificent windows, and then I saw this natural photo-montage

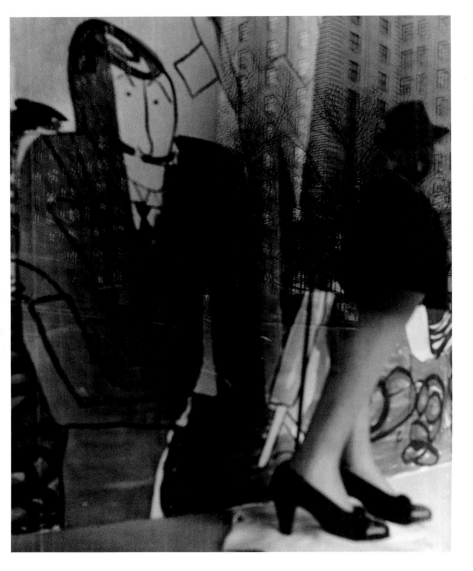

'Reflections', New York, 1939–45. In December 1940, two years after her arriv[...] in the US, several of Model's 'Reflections' photographs were reproduced [...] the magazine *Cue*. The selection, entitled 'Plate Glass Phantasia', was her fir[...] published work in an American magazine. The image recalls the experiment[...] photomontages of the 1920s Russian artists El Lissitsky and Klutsis, where life[...] sized open hands were surrogates for the complete human figure. Less politic[...] and theoretical than these artists, Model enjoyed the complexity that the phot[...] graph could serendipitously provide. This image contains the reflection of he[...] own hand. The eroticism of her polished, tapering nails dominates the layere[...] planes of the street scene, over which the mannequin in the shop window seem[...] to preside.

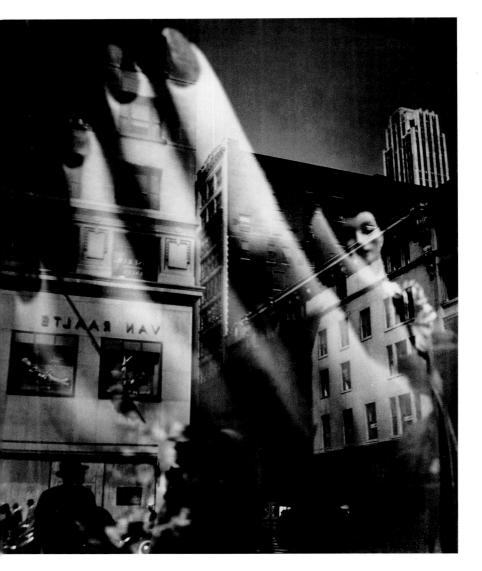

'Reflections', New York, 1939–45. The contents of this shop window on Fif[th] Avenue are obscured, emphasizing the abstract qualities of composition an[d] tonality of light and dark, shadow and silhouette. This photograph projects no sens[e] of the joy of shopping in the city. The grim expressions on the pedestrians' face[s] and the somewhat menacing profiles of people seen in shadow convey a sense [of] foreboding. Taken in wartime, the photograph catches the tension in the air.

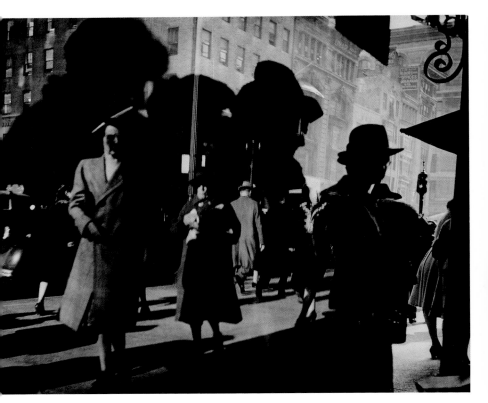

Lower East Side, New York, 1939–45. By the 1890s, the Lower East Side are
of Manhattan, bounded by 14th Street and the East River, had become one of th
most densely inhabited parts of New York, home to immigrant Italians, Easter
European Jews, Russians, Romanians, Hungarians, Ukranians, Slovaks, Greek
and Poles. From the turn of the century, the neighbourhood had attracted artis
and photographers. Some captured the picturesque qualities of its peddlers, push
carts and bustling streets; others took documentary photographs focusing on i
poverty, aimed at achieving social reform. The well-dressed subject of Model
photograph, who sits on a chair apparently observing street activity, was known a
the Mayor of Delancey Street, one of the main thoroughfares of the area.

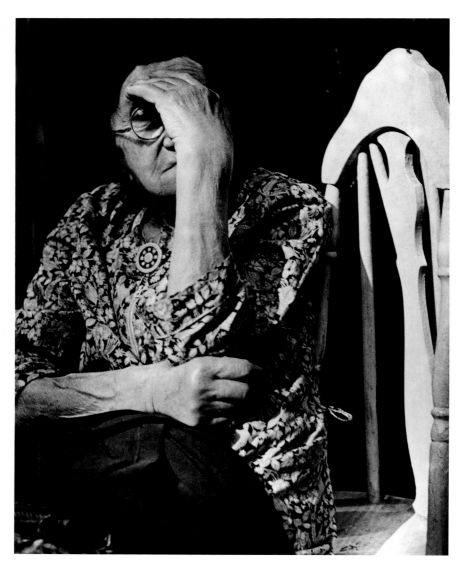

Lower East Side, New York, 1939–45. Model managed to record the Lower East Side without sentimentality. Her eye is neither for the anecdotal nor the documentary. She looks for solitary figures rather than vignettes or situations. This woman, with her bag, outstretched hand and frowzy hair, is nonetheless fully attired from top to toe, albeit in clothes of the most pitiful condition. Her expression is contained, almost ennobled, not abject. If she is a beggar, then she is also shown to possess an ineffable elegance.

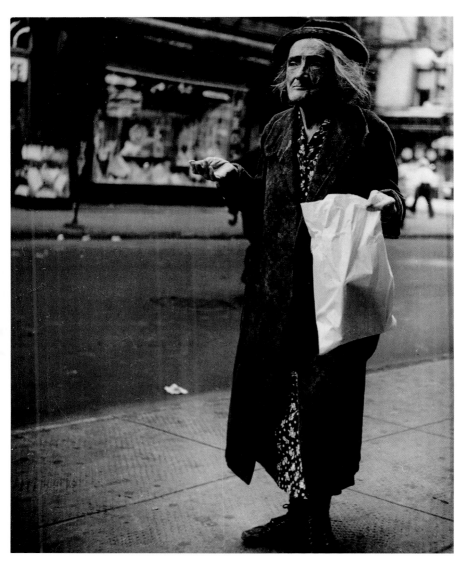

Delancey Street, New York, 1942. Model cropped the margins of this photograph so that the pram is fragmented, the curves of its wheels, handles and crescent-shaped body corresponding with the rotund, round-faced man who sleeps alongside his charge. Such attention to form in her images was typical of Model. An ironic detail is provided by the advertisement, hanging upside-down in the window, which announces entertainments – a balalaika performance and a film called *Go West Young Man*. The prospect of enjoying these lively spectacles seems far removed from the experience of this young man, slumped in deep repose or exhaustion.

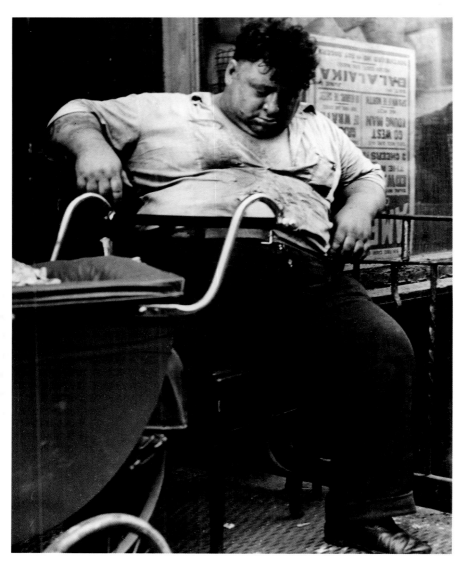

Lower East Side, New York, c.1942. Model made two portraits of this woma
wrapped in a knitted shawl. Both are taken from below, looking up at her shor
round body from the street. In this one, Model's emphasis is on the woman
emphatic gesture and face, captured as she speaks. One can almost hear th
language, which was undoubtedly not English. Model spoke of her warmth fc
the Lower East Side, with its similarities to the streets and people of Europ
that she had left behind. A selection of her Lower East Side photographs ha
probably been shown in 1941 at the Photo League, an organization founded
1936 by New York photographers who devoted their efforts to documenting li
in the city, particularly its working-class neighbourhoods. Model attende
classes and exhibited at the Photo League during the 1940s.

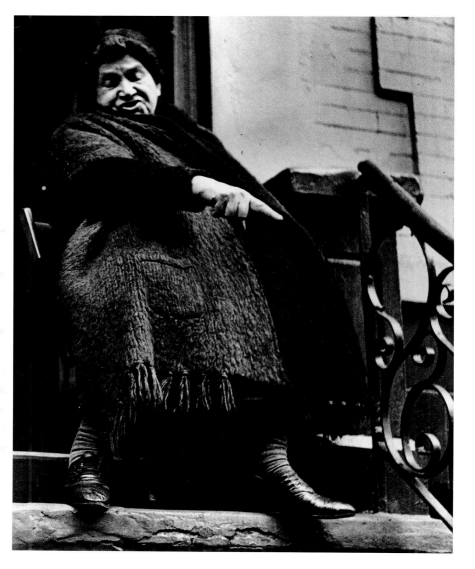

Valeska Gert, 'Death', 1940. Valeska Gert's face is like a tragic mask. Mod[...] appears to have asked her to stage a performance for the camera. The milieu [...] Expressionist dance, an Austro-German phenomenon from between the war[...] was familiar to Model, who was a friend of Gert, another émigré artist. Th[...] anguished, screaming mouth and hands thrown up to the head are striking[...] reminiscent of Edvard Munch's famous Expressionist painting *The Scream*.

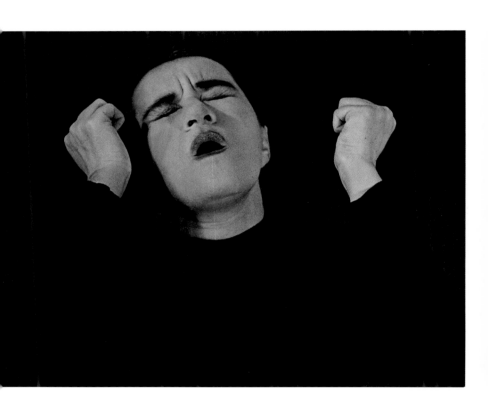

Valeska Gert, 'Olé', 1940. Model's photographs of Gert were not meant show beauty and grace as a standard of her dance. The extreme close-up he emphasizes the dancer's taut, swinging torso, her angled arms, strain jaw and intense facial expression. The body is not fully revealed, but the clo cropping emphasizes just enough gesture and movement to suggest the rhyth of the action. Newly arrived from Europe when she took this photograph, Moc must have identified with Gert as a strongly European figure. However, t longer she lived in the country, the more she seemed to be attracted 'American' subjects.

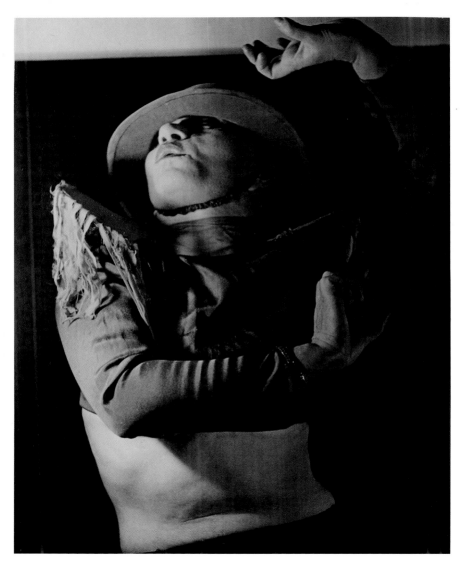

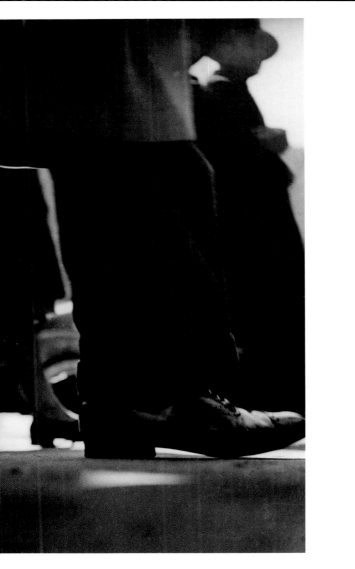

(previous page) **'Running Legs', 42nd Street, New York, 1940–1.** Crowds are usually photographed at eye-level or above. Here, what information we are given refers only to feet and legs in motion. Between 1940 and 1941, Model made many photographs in which the focus was legs, either of a solitary walker or groups of people. The point of view of the camera in these photographs is extremely low, almost from beneath the level of the street. In this image, the man's trousered legs frame a deep perspective across the city pavement with other walkers beyond. The title she gave this series, 'Running Legs', suggests that Model wanted to convey a sense of the pace that must have embodied New York for her.

'Running Legs', Fifth Avenue, New York, 1940–1. There is an erotic charge to this image of a slim leg and high-heeled shoe. The female figure, who is bisected by the top border of the photograph, is in motion. Out of the context of the 'Running Legs' series, this photograph could be identified as a fashion shot and is reminiscent of the action-based style of Martin Munkacsi, whose work was featured in *Harper's Bazaar* from the late 1930s.

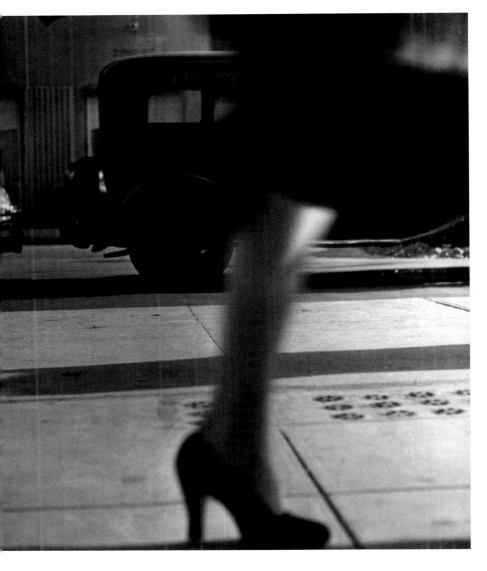

'Running Legs', New York, 1940–1. Model cropped her photographs in order to find passages of abstracted pattern such as this. Abstract forms and contrasting grey and black tonalities constitute an image hardly recognizable as a fragmented view of overcoat, legs, shadow and pavement. Model certainly had an interest in modernist abstraction (her husband Evsa, an abstract artist, had shown at the Sidney Janis gallery in 1948); all of her prints are strong graphic organizations. Yet she never abandoned her figurative approach, suggesting that, to her, the context of the photograph was important.

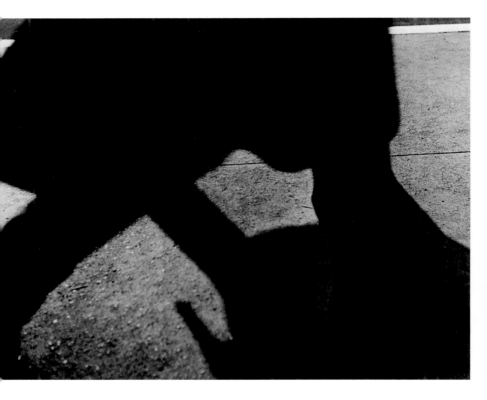

'Sammy's', New York, 1940–4. Sammy's was a club at 267 The Bowery, a derelic
street in downtown New York, owned by fellow-Austrian Sammy Fuchs. Here
neighbourhood bums mixed with uptown customers. The entertainment provide
by the regulars was the antithesis of slick cabaret. In this image, th
two smoking women and their companions represent the extremes of th
clientele. Through her formal manipulations, Model achieves a sense of th
fizzy, intoxicated atmosphere and the sleazy glamour of this bar. The pictur
resembling a photomontage, combines isolated vignettes into one image b
tilting the viewpoint off-centre, either while shooting or in printing or cropping.

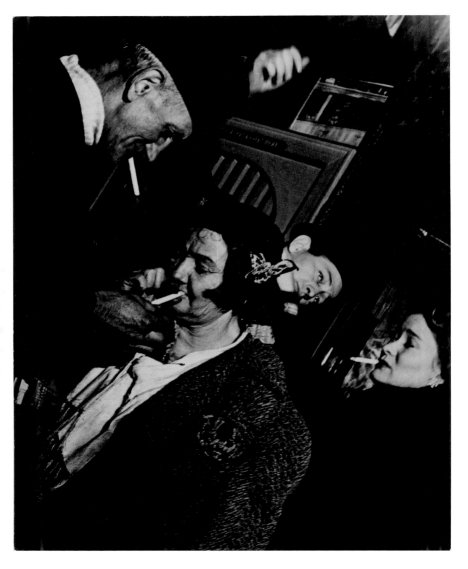

'Sammy's', New York, 1940–4. Although New York certainly had its version of high society, Model, like many Europeans, was attracted to the vaudeville saloons and restaurants of working-class, old New York. Acknowledging the chicness of slumming it by going downtown to a colourful bar, *Harper's Bazaar* published Model's photographs of Sammy's in September 1944 in 'Sammy's on the Bowery', a two-page collage. 'Take Tilley on the left,' the text read, referring to the woman singing into the microphone, 'Bowery Old Timers claim her voice has had no match for power and ferocity since Maggie Cline used to stun with "Knock 'Em Down McCloskey".' Model printed this image both tilted and straight.

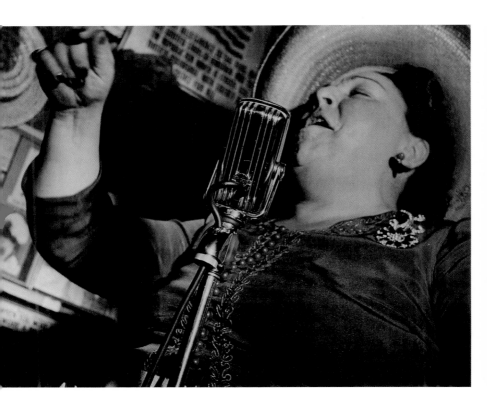

'Sammy's', New York, 1940–4. This mismatched couple, a young, fresh-faced gu
and a glassy-eyed, probably drunk woman in worn-out clothes, are locke
together in an embrace that keeps her from falling to the floor. He grins for h
portrait; she seems oblivious to the photographer. Model's pictures of Sammy
were the first of a considerable number devoted to nightlife and theatric
entertainment, mostly taken in New York. Brassaï's photographs of Paris a
night may be a precedent for this work. Like him, she was drawn to cafés an
cabarets and their clientele, the population of the city that emerged after dar
Model exploited the lack of available light in Sammy's interior during its noctur
nal hours, taking these photographs with the aid of an electronic flash.

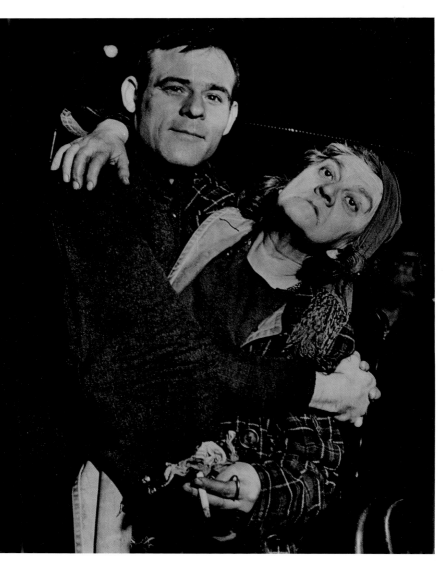

'Sammy's', New York, 1940–4. The 'Sammy's' series does not celebrate romanti
sexual intimacy. Model saw the bar's habitués through the ironic eye of th
satirist. The couple in this vignette were probably together only for the night o
the sailor's leave. The woman's fur and stiff-flowered hat are a garden of earthl
delights to the sleekly coiffed, mustachioed sailor who sniffs around them like
bee attracted to honey.

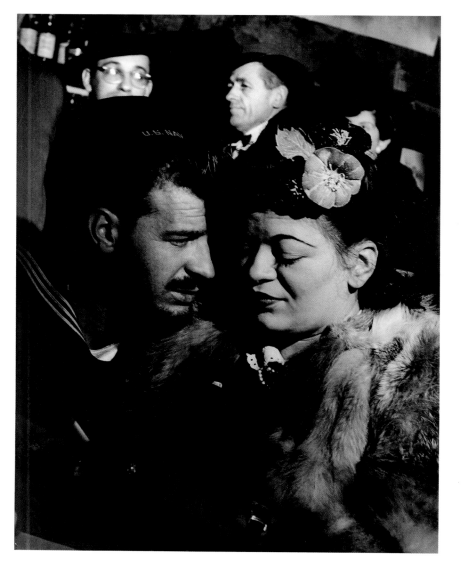

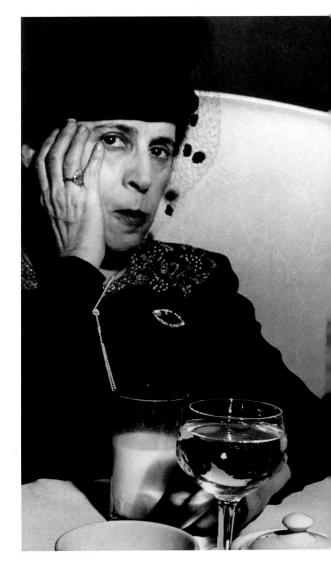

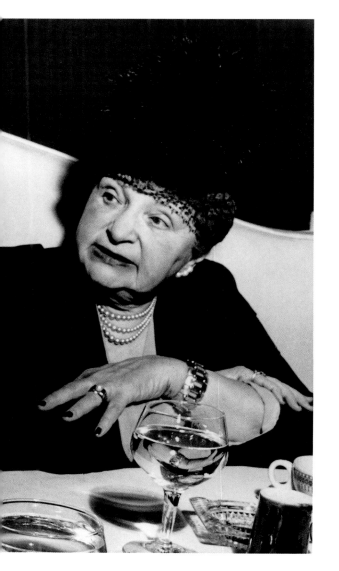

(previous page) Fashion Show, Hotel Pierre, New York, 1940–6. Although she worked on assignment for a fashion magazine, Model did not take catwalk shots. Her interest in glamour was undeniable, but in this photograph and many others she is interested in the effects of glamour on its consumers, the women who dwell in its aura. The clutter of dishes on the table echoes the clutter of the women's outfits – jewellery, hats, veils – which seem to clash with the svelte luxury of the Hotel Pierre on Fifth Avenue and the stylish models they are watching. Model reveals a certain scepticism in these women's facial responses, echoed by the telltale detail of the glass of wine pushed back in favour of the simple glass of milk.

Murray Hill Hotel, New York, 1940–5. Formerly the destination of presidents, this once-grand hotel on Park Avenue became a residential hotel and was scheduled for demolition. Model took a series of portraits of its residents, conveying the aura of grandeur that has declined into austerity. This photograph is a good example of the simple style of portraiture Model developed. She deliberately left the interiors unlit, not highlighting in any way the marble floors, gilt-framed mirrors and rococo walls. There is nothing on the table or background walls to distract interest from the man's face and gesture. Still respectable and shabbily elegant, he stares off into the distance, the emptiness of the table and walls evoking the pathos of the impending loss of his home.

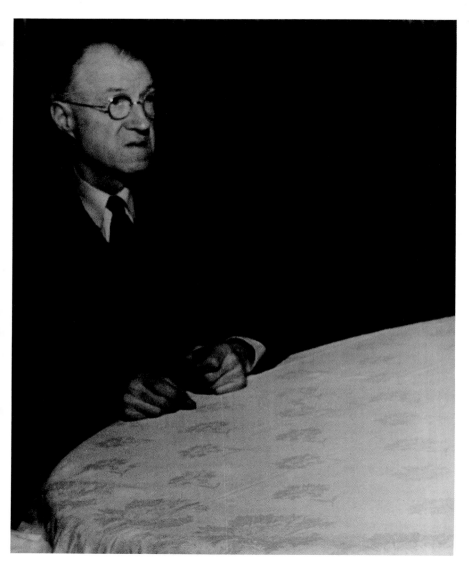

War Rally, New York, 1941–2. This photograph, along with six others of war rallies, was published accompanying the article 'Their Boys are Fighting' i *Look* magazine, November 1942. Along with *Life* magazine, *Look* was influentia in the development of photojournalism in the United States. Presumably, th subject of the photograph is the father of a soldier serving in battle. Model ha done nothing to deflect from his monumental appearance. His expressio reveals patriotism and concern, but his folded arms betray a trace of resigna tion and he does not wave his flag with enthusiasm. In photographing wa rallies, Model was finding new subject matter in the theatre of the New Yor streets, although these standard civic subjects were never her forte.

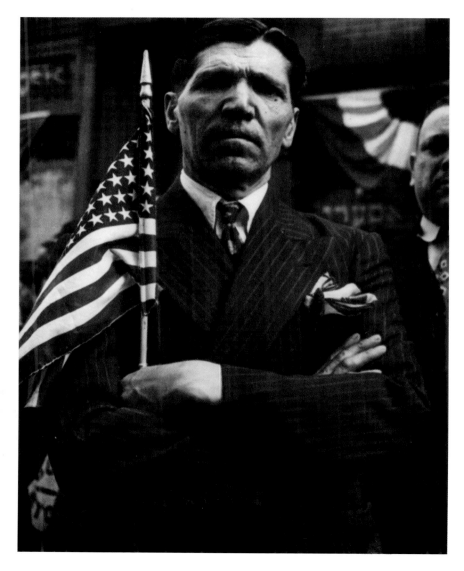

Gallagher's, New York, 1944. Model was drawn to places in New York wher
people gathered in the evening. It was this pleasure-seeking nightlife, similar t
that of European capitals – particularly Paris – that gave New York its characte
Here, in the old steakhouse Gallagher's, a female patron, attired in a ligh
reflecting brocade jacket, is rapt in conversation. As captivating as her face i
in this portrait, it is her astonishingly beautiful hands – long and graceful wit
polished nails – that draw the eye. Model captures the essence of the casua
sexuality of public metropolitan spaces in the woman's gesture as she lifts
cocktail, ready to enjoy the night.

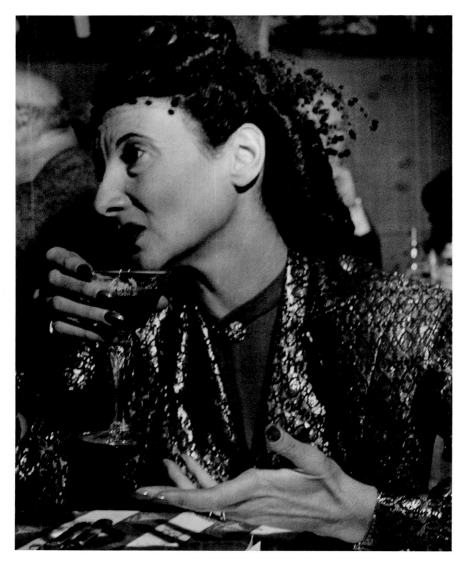

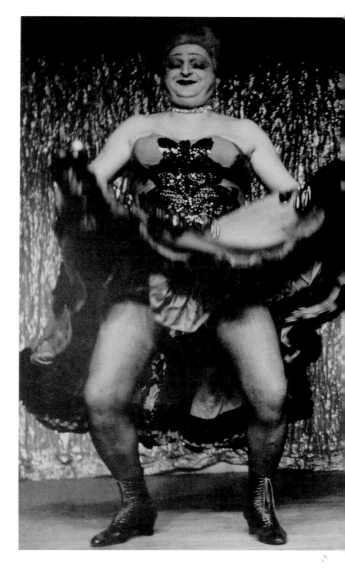

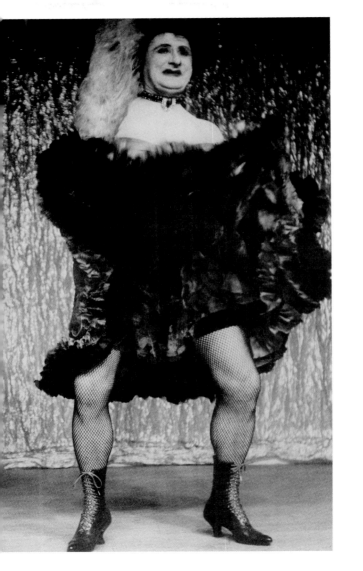

(previous page) Female Impersonators, c.1945. During the 1920s, transvestite balls were held across New York, in Madison Garden, Times Square and midtown hotels, as well as in the Village and Harlem. Thousands were attracted, and the city rivalled Berlin for its tolerant attitude. By the 1930s, however, the balls were moved to the peripheries. The strong theatricality of this entertainment and the burlesque glamour of the cross-dressing men attracted Model, who may have known of Brassaï's photographs of the bordellos, homosexual bars, dance halls and opium dens of Paris taken in the 1930s. Here, she photographs two cancan dancers who are clearly past their prime. Blatantly bald, lavishly made up and attired in *fin-de-siècle* strapless dresses and high-laced boots, they flirtatiously lift their skirts.

Diana Vreeland, New York, c.1945. The celebrity or society snapshot was a staple of New York photojournalism. However, Model's photograph of *Harper's Bazaar* editor Diana Vreeland and her dinner companion is unlike the usual example of this genre, which were often more posed and flattering to their subjects. Instead, it is candid and psychologically complex. Vreeland acknowledges the photographer, appearing open to her gaze. But her companion seems unaware of either the photographer or of the glamorous Vreeland, despite her attention grabbing, bangled arms. The plentiful sources of intoxication that surround them — the cocktails and glasses of wine — seem to be equally uninteresting to him.

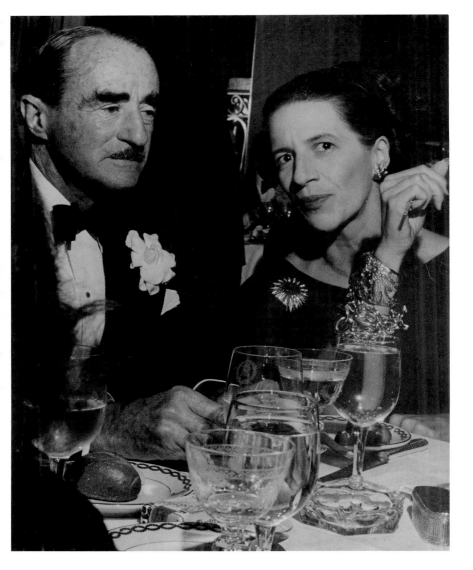

Albert-Alberta, Hubert's 42nd Street Flea Circus, New York, c.1945. Mod
was not particularly attracted either to gay subculture or to 'freaks'. Th
hermaphroditic figure must have intrigued her for his/her humorous take c
glamour, the female vamp side signalled by elaborate make-up, a see-throug
'bra' and a satin, fur-trimmed cape. Model photographed Albert-Alberta a
Hubert's on 42nd Street, a club well-known for its freak display, which was fre
quented later by her student Diane Arbus.

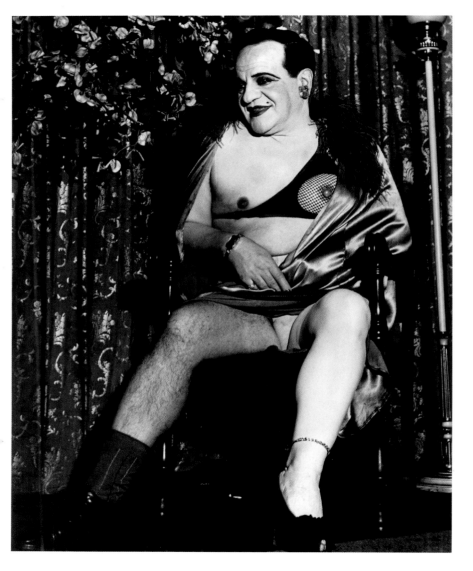

Circus, New York, 1945. This photograph, taken for *Harper's Bazaar*, capture[s] an instant in a remarkable circus act where tightrope performers on bicycle[s] balance a chair holding a man, who in turn supports a woman on his shoulder[s.] The cyclists carry their burden from one station to another, on each [of] which a woman waits in order to mount the top of the pyramid. Spread wa[y] below at the foot of the circus tent is a tarpaulin, held tight by attendants, [in] case one of the performers should fall. In addition to achieving a spectacula[r] contrast of light and dark, Model has also created a wonderful metaphor fo[r] the beauty of photography, which, like no other art, captures the drama of [a] single, arrested instant.

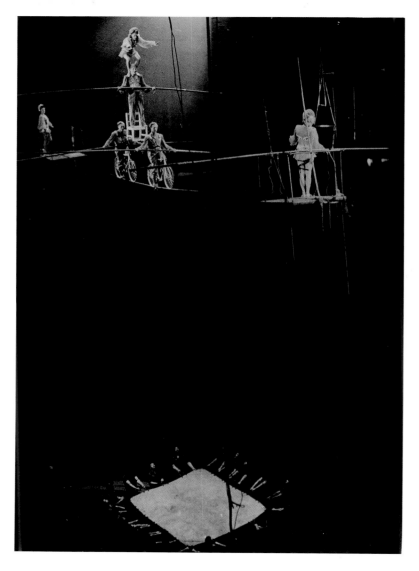

Café Metropole, New York, c.1946. Model firmly believed in the manipulatio of negatives during the printing process by enlarging, cropping, burning-in an dodging. Although the subject matter of her photographs was always he greatest interest, she had begun her photographic career by learning dark room techniques and expected to make her living as a darkroom assistant. Th dynamism of this photograph of a performer seemingly electrified by the joy c her own rendition is enhanced by Model tilting the picture plane.

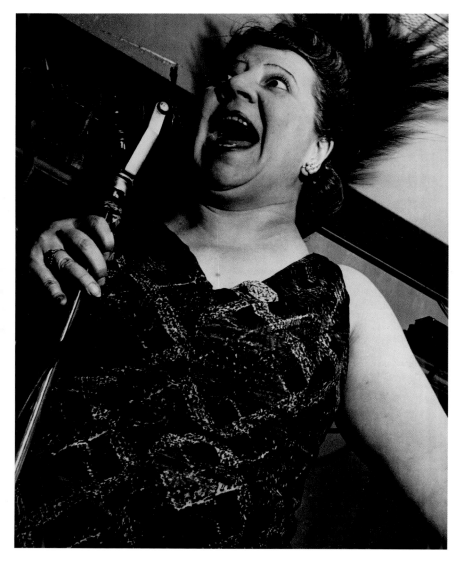

Westminster Kennel Club Dog Show, New York, February 1946. Here, Mode
captures the complexity of relationships in the essential form of human and dog
The image focuses on the contrast between the eyes of the owner, close
in rapture or in sleep, and the alert eye of the Boston terrier. The dog seem
to exhibit a forbidden desire for freedom from the encircling arms, while th
'mistress' remains unaware of the true wishes of her 'best friend'. Set in
distinctly upper-class milieu, as social allegory the image seems to undermin
the possibility of personal loyalty in the companions of the wealthy.

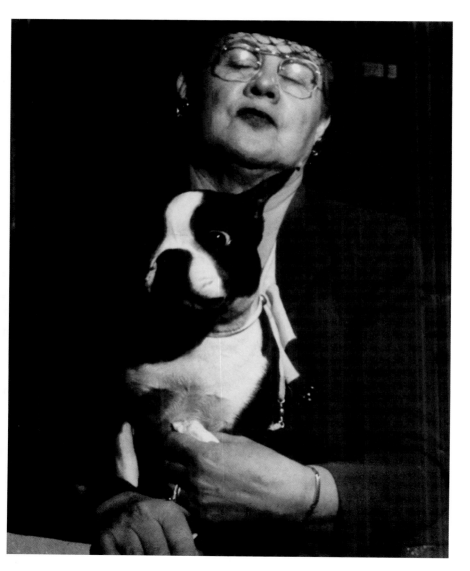

International Refugee Organization Auction, New York, 1948. This poignan photograph of an elegant, elderly man resembles Degas' portraits of his fathe in old age. It is part of a series of pictures taken of people attending th International Refugee Organization auction, which Model photographed as personal project. After the war, New York sustained a large community refugees who had sacrificed their homes and professions to avoid slaughter ar who had no steady form of support. Model sympathized with these refugees, wh like herself, found themselves in the 'land of opportunity', yet were unable maintain the comfort of life they had known before the war. In their formal dres they appear as paler versions of their former selves, their present poverty dis guised by their once-grand attire.

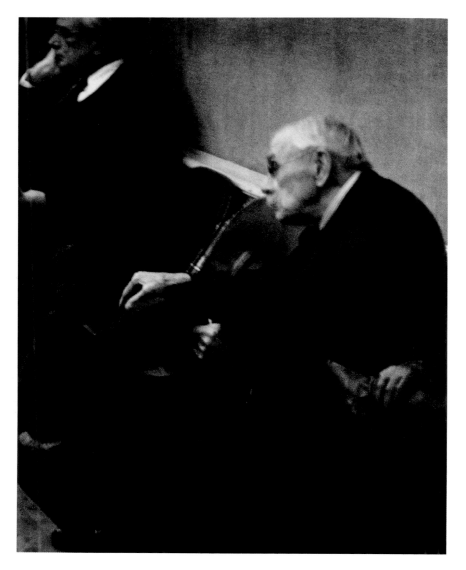

Woman with Veil, San Francisco, 1949. In this photograph, Model revels in the multiplicity of the textures piled on by her subject to enhance her feminine appeal: the fake flowers of the hat, the fresh-flower corsage, the lace collar the fur coat. But it is the delicate netting of the woman's veil, which reads sharply against the blurred grey tonalities of the background, that creates the metaphoric punch of the work, conveying the ultimate fragility of this woman's hold on beauty. Its lightness is, paradoxically, armour against the onslaught of age.

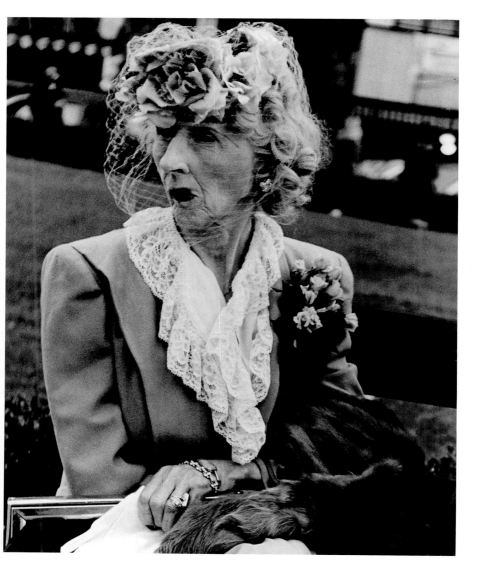

San Francisco, 1949. Model was often extremely formal in her approach t
a picture's composition. This photograph was taken in San Francisco, where sh
went to teach at the California School of Fine Arts. While there, she photo
graphed the city in a seemingly casual manner with a small camera. Here, wit
the most minimal composition, she captures the particular drama of pedestria
life in San Francisco where very steep streets are a challenge. She has tilte
her negative to dramatize the upward slant of the road, navigated by a walker
and cropped the top of the image to highlight a car parked in downward pitch
defying gravity.

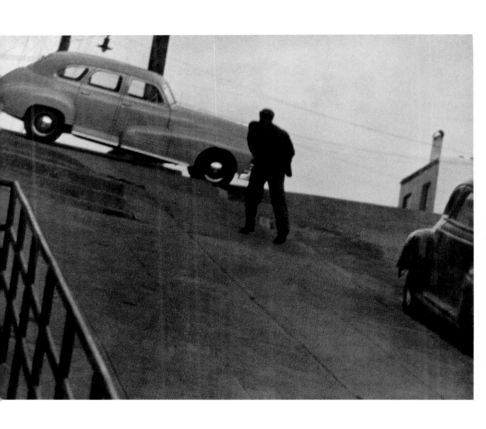

Reno, 1949. Model was selected by John Morris, Picture Editor of *Ladies Hom* *Journal*, to photograph women who established residence in Nevada in orde to get a divorce. In 1940s America, this was the only state that granted them The photographs were published to illustrate the article 'How Reno Lives' an were part of the series 'How America Lives'. In some ways, this portrait echoe Model's portrait of the world-weary blonde taken on the French Riviera i the 1930s. The reflections in the sunglasses, however, give this later pictur a greater psychological complexity. The sunglasses not only act as a defenc against the outside world, but also reflect it. In an interpretation of th social situation of divorce, they render the woman simultaneously withdraw and vulnerable.

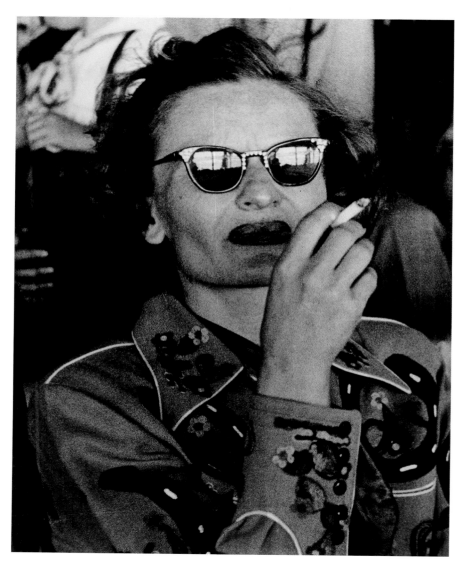

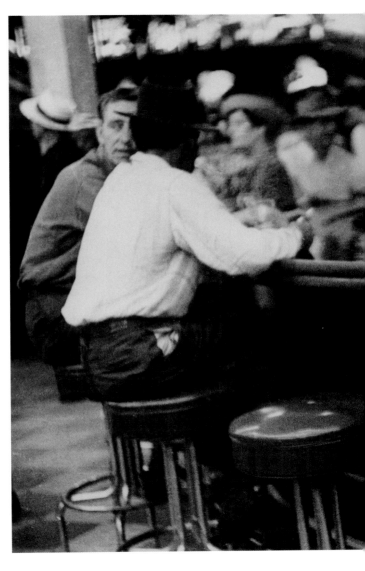

(previous page) Las Vegas, c.1949. As this photograph shows, the women wh[o] moved to Nevada to obtain their divorces dressed differently from the local appearing like exotic birds in the landscape. Model did not consider herself documentary photographer, but the psychological and sexual situation of thes[e] women appealed to her.

Evsa Model, New York, c.1950. Model's work is largely unencumbered by refer[e]nces to her own biography. She was not at all interested in the self-portrait. Y[et] throughout their lives together, she periodically photographed her husband Evs[a.] At about the time of this portrait, Evsa stopped exhibiting his painting at galle[ry] shows, although up until 1948 he had shown sporadically in New York and ha[d] been associated with other artists such as Fernand Leger and Piet Mondria[n.] He spent the next twenty-five years painting and teaching from his apartment New York, supported by the small earnings of his wife. This simple portra[it] demonstrates her husband's strong good looks and characteristic stoicism.

Rome, 1953. When she returned to Europe in 1953, Model did not just photo graph people as she had done before. She also began to depict the famou monuments of Rome. The ruined sculpture of antiquity yielded images of gre psychological and formal complexity. Here, it is the fortuitous juxtaposition two stone sculptures, unequal in scale, that captures her attention. Since th hand fragment is paradoxically bigger than the standing figure, it takes on a oracular status and the photograph becomes a found allegory.

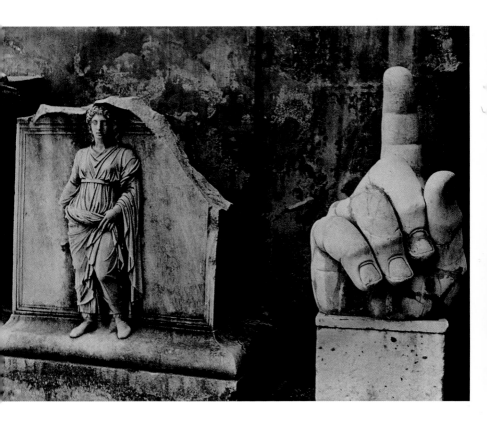

Mummy in a Museum, Rome, 1953. Even when representing death, Model's eye is drawn to visual and cultural complexities. In this image, the mummified body, its large head overwhelming the desiccated limbs, is given an incongruous modern resting place — a transparent Plexiglas coffin with rounded ends and curved legs. The sharp horizontal of the body contrasts with the kinetic design of the antique mosaic floor and with the square shapes of Roman reliefs against the far wall. Through Model's vision, death seems out of place in the welter of contemporary and ancient forms, and yet in its contrasting darkness and horizontality, remains an overwhelming fact.

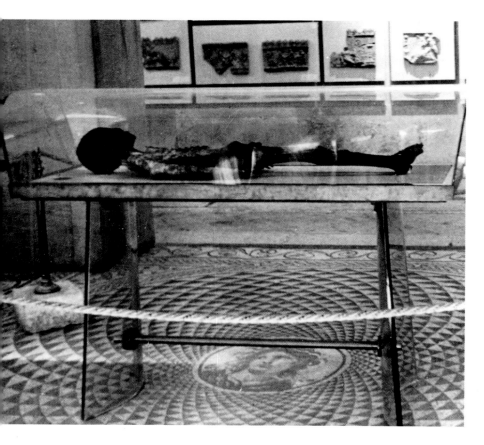

Studio of Armando Reveron, Venezuela, 1954. On her trip to Venezuela in 195
Model was attracted to the complex cultural mix of the country and especial
to the work of Armando Reveron, an artist who exemplified a distinctly nor
European, more naive and popular art. And yet this example of Reveron's wor
a life-size figure, resonates with Model's own artistic project. The shabby, i
fitting dress, the puffy wrinkled 'skin', the distorted elbows and dislocate
fingers and toes, echo the 1940s photographs of the toil-worn women of th
Lower East Side.

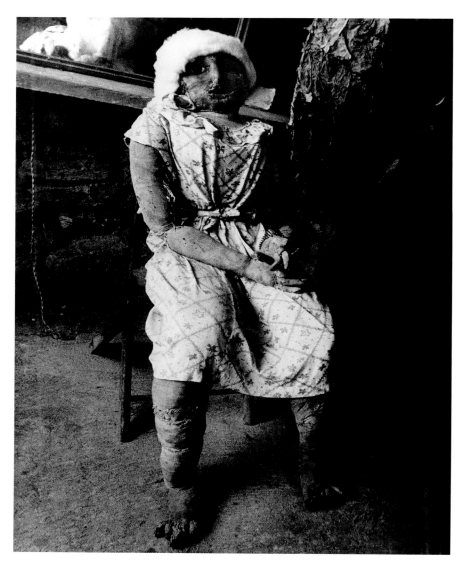

Ella Fitzgerald, c.1954. This monumental image of Ella Fitzgerald epitomize Model's attraction to the power of the African-American musical tradition. He 1950s photos of jazz performers reveal the photographer as a European payin tribute to this uniquely American musical force. Shot in close-up, the singer' body takes up most of the picture space. The low point of view is that of th spectator, the admirer – almost the worshipper. The head is thrown back, th mouth open, the eyes closed in the traditional pose of ecstasy, the singer wholl absorbed in the intensity of her performance.

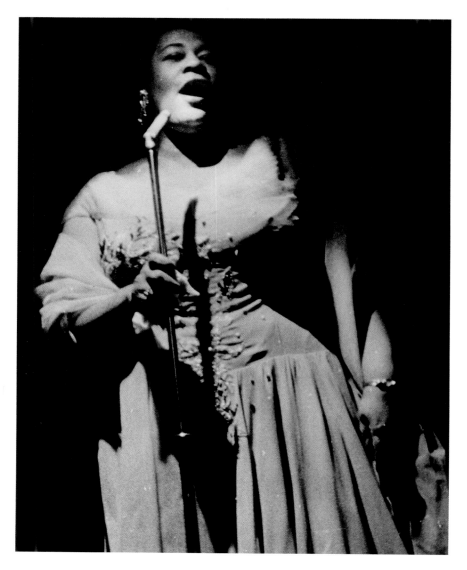

Horace Silver, Newport Jazz Festival, Rhode Island, USA, 1954–6. Model performance photographs form an interesting component of her work, demonstrating her sensitivity to a broad span of entertainment from the Expressionist cabaret of her youth, through the amateur singers at Sammy's, to the outdoor jazz festivals of the 1950s. In these performance photographs, Model obviously found a metaphor for the joy that art could convey when released from the elitist, avant-garde circles of 1920s Europe and made available, in the form of jazz, to the fans of postwar America. Horace Silver was part of the generation that brought be-bop to large audiences. His posture at the piano was a signature of his performance. Model captures the angles of his torso, twisted towards the keyboard.

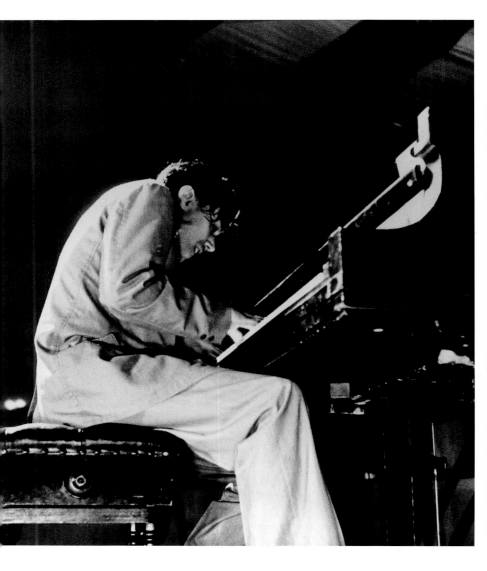

Billie Holiday, New York, 1959. If Model's jazz photos of the 1950s capture the intensity of performance, here the great jazz singer Billie Holiday, known for her extraordinary emotive range, is figured as quiet in death as sleep. If the performance photographs show the moment of passion expressed through music, in this image the moment is that of passion past. The performance pictures set the musicians against the dark background of dimly lit interiors. Here, Holiday's face is in sharp focus, given a hard-edged realism, while the surroundings are in blurred, soft focus, a cloud of white suggesting a secular apotheosis. The image is remarkably peaceful, as if Model is presenting the singer's death as transcendence, an escape from the harshness of American life.

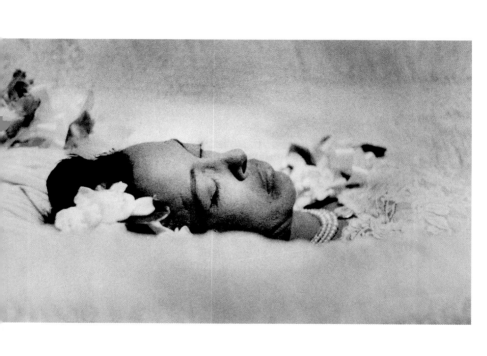

1901 Born Elise Seybert, 10 November, Vienna, to affluent bourgeois family

1920–1921 Studies music with experimental composer Arnold Schoenberg.

1924 Death of her father Victor Seybert from heart failure.

1926 Moves to Paris with her mother and sister. Studies singing.

1933 Suddenly abandons music. Takes up painting and studies briefly with the painter and art critic André Lhote. Decides to train as a darkroom technician to earn a living. Taught to photograph by younger sister Olga, as well as by André Kertész and his first wife Rogi André. Her first subjects are Parisian street scenes and people.

1934 Visits her mother, who is now living in Nice, and begins her series 'Promenade des Anglais', a critical study of the rich bourgeoisie. Meets Evsa Model, a Russian graphic designer and painter.

1935 'Promenade des Anglais' is published in French journal *Regards*.

1937 Marries Evsa Model in Paris.

1938 Visits New York with Evsa and they decide to settle there.

1939 Begins experimental series of photographs 'Reflections' and 'Running Legs', inspired by the streets of New York. Also photographs Delancey Street, Battery Park and Wall Street.

1940 Her work is seen by Ralph Steiner, Art Director of *PM's Weekly* and Alexey Brodovitch, Art Director of *Harper's Bazaar*. They introduce her to Beaumont Newhall, curator of newly formed department of photography at the Museum of Modern Art, New York. Newhall includes one of her photographs in the inaugural exhibition and buys some of her work for the museum.

1941 Given first solo exhibition by the Photo League, whose other members include Berenice Abbott and Weegee. One of her most famous images, *Coney Island Bather*, is used to illustrate an article in *Harper's Bazaar*. This is her first assignment for the magazine.

1943 Moves to Greenwich Village. Photographs Lower East Side extensively. Exhibition held at the Art Institute of Chicago.

1944 *Harper's Bazaar* publishes 'Sammy's', a series of photographs of this bar in the Bowery, New York.

46–1948 Makes photo-essays on the Westminster Kennel Club dog show and the International Refugees Auction in New York. Scales down work for *Harper's Bazaar* in the face of its growing conservatism.

1949 Makes photo-essay for *Ladies Home Journal* about divorce in Reno. Her work is selected by the Museum of Modern Art, New York, for travelling exhibition 'Leading Photographers'. Begins teaching at the California School of Fine Arts, San Francisco.

1950 Participates in the symposium 'What is Modern Photography?', Museum of Modern Art, chaired by Edward Steichen.

1951 Begins teaching at the New School for Social Research, where her pupils include Larry Fink, Bruce Weber and Diane Arbus.

1953 Returns to Europe for the first time. Begins series depicting the monuments of Rome.

54–1956 Photographs jazz performers at Newport Jazz Festival, Rhode Island.

1955 Her work is included in Steichen's 'Family of Man' exhibition. Stops working for *Harper's Bazaar*.

1964 Wins Guggenheim Fellowship for 'Glamour: The Image of Our Image'.

1976 Begins lecturing on her work. Evsa Model dies from a heart attack.

1977 Issue of *Camera* devoted to her life and work.

1981 Awarded honorary Doctor of Fine Arts by New York School for Social Research.

1982 Subject of a major retrospective at the New Orleans Museum of Art.

1983 Dies in Greenwich Village, New York.

Photography is the visual medium of the modern world. As a means of recording, and as an art form in its own right, it pervades our lives and shapes our perceptions.

55 is a new series of beautifully produced, pocket-sized books that acknowledge and celebrate all styles and all aspects of photography.

Just as Penguin books found a new market for fiction in the 1930s, so, at the start of a new century, Phaidon **55**s, accessible to everyone, will reach a new, visually aware contemporary audience. Each volume of 128 pages focuses on the life's work of an individual master and contains an informative introduction and 55 key works accompanied by extended captions.

As part of an ongoing program, each **55** offers a story of modern life.

Lisette Model (1901–83) began her photographic career in Europe but moved to New York in 1938, where she embarked on a lifelong project 'to photograph America's self portrait a million times projected and reflected'. From the 1950s she was an influential teacher of photography, her students including Diane Arbus, Robert Mapplethorpe and Bruce Weber.

Elisabeth Sussman has been Curator of the San Francisco Museum of Modern Art and the Whitney Museum of American Art, New York, amongst others. Her publications include *Nan Goldin: I'll Be Your Mirror* (1996).

Phaidon Press Limited
Regent's Wharf
All Saints Street
London N1 9PA

Phaidon Press Inc.
180 Varick Street
New York NY 10014
www.phaidon.com

First published 2001
©2001 Phaidon Press Limited

ISBN 0 7148 4061 0

Designed by Julia Hasting
Printed in Hong Kong

Photographs by permission of: The National Gallery of Canada, Ottawa; The J. Paul Getty Museum, California; The Estate of Robert Mapplethorpe; The Lisette Model Foundation; The Special Collections of Edward Downe and Norman and Carolyn Carr, National Gallery of Canada, Ottawa. Thanks to Marisa Cardinale for her help.